CANYONS OF THE TEXAS HIGH PLAINS

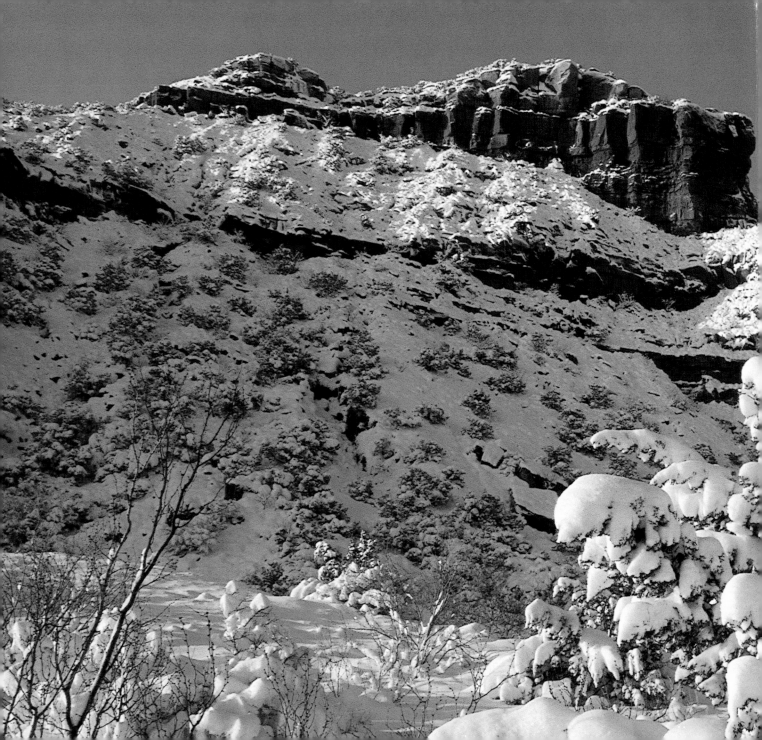

CANYONS OF THE TEXAS HIGH PLAINS
WYMAN MEINZER

—INTRODUCTION BY—
FREDERICK W. RATHJEN

TEXAS TECH UNIVERSITY PRESS

© Copyright 2001 Texas Tech University Press

This book was set in Palatino and Copperplate Gothic. The paper used in this book meets the minimum requirements of ANSI/NISO Z39.48-1992 (R1997). ⊗

Previous page: Caprock Canyon State Park—Canon F1 with AE motor drive; Canon 20-35mm f/3.5L; Fujichrome Velvia

Printed in China

Design by Brandi Price

Library of Congress Cataloging-in-Publication Data
Meinzer, Wyman.
 Canyons of the Texas High Plains / Wyman Meinzer ; introduction by Frederick W. Rathjen.
 p. cm.
 ISBN 0-89672-462-X (cloth : acid-free paper). — ISBN 0-89672-463-8 (paper : acid-free paper)
 1. Texas Panhandle (Tex.)--Pictorial works. 2. Canyons—Texas—Texas Panhandle—Pictorial works. 3. Landscape—Texas—Texas Panhandle—Pictorial works. 4. High Plains (U.S.)—Pictorial works. 5. Landscape photography—Texas—Texas Panhandle. I. Title.
 F392.P168 M45 2001
 976.4'8--dc21
 2001002380

01 02 03 04 05 06 07 08 09 / 9 8 7 6 5 4 3 2 1

Texas Tech University Press
Box 41037
Lubbock, Texas 79409-1037 USA

1-800-832-4042
ttup@ttu.edu
www.ttup.ttu.edu

To those unheralded Texans whose ongoing stewardship continues to preserve the integrity of our state's natural heritage. And to the Native Americans whose spirits still reside in the recesses of these High Plains canyonlands.

ACKNOWLEDGMENTS

In a photographic career spanning two decades, I have been fortunate in having opportunities to travel and experience the land and people in every region of the state of Texas. Without fail, the success of my endeavors has required the help of hundreds of people who act as stewards of our wonderful park system or owners of the expansive ranches throughout the state. I would like to extend my humble thanks to Andrew Sansom, executive director of the Texas Parks and Wildlife Department, for his tireless efforts in maintaining and expanding the integrity and natural beauty of our state parks, and to the dedicated Parks and Wildlife employees of Palo Duro Canyon and Caprock Canyon State Parks who continue to make these parks priceless examples of the great canyon-lands for the benefit of visitors worldwide. I extend my heartfelt gratitude to my friend, educator and author Fred Rathjen, who so graciously gave voice to the fascinating story of the canyonlands in the introduction to this collection. I applaud the efforts of private ranchers throughout the region who also possess a love and appreciation for the history and aesthetic value of the canyons that exist both within and outside of the boundaries of their land holdings. And last, I would like to extend my thanks to a dear friend, fellow adventurer and plainsman Knut Mjolhus, who has walked the trails and shared my fascination for the magnificent presence of these High Plains canyonlands.

—Introduction—

Atraveler between Amarillo and Lubbock via I-27 may notice, near the town of Tulia, three creeks or draws: North Tule, Middle Tule, and South Tule. A native will probably pay little attention because he or she knows they are there and where they lead, and therefore take them casually. On the other hand, a traveler not familiar with the country may never notice the identifying highway markers, much less the creek. A more observant traveler might notice the signs and wonder, "Where is the creek? I don't see any creek." One who wonders such a thing assumes that if there is a creek, there must be water. Sometimes there is, but if West Texans know anything, it is that you don't have to have water to have a creek, or even a river. Failure to understand that principle naturally confuses the novice, and on the part of some long-term plainsmen, both historically and currently, has caused no end of mischief throughout the Great Plains and Southwest.

The three Tule draws are like hundreds of similar ones upon the uplands surrounding the High Plains canyonlands: they initiate the marvelously intricate, complex topographic wonder of the canyons. Every insignificant draw, small box canyon, or barely noticeable waterless

drainage contributes to that geological wonder; the only way truly to comprehend the giant topographical complexity is to see it from the air. Only from high above can one grasp the totality of topographic relationships in the canyonlands and appreciate the massive complexes extending eastward from the escarpment of the High Plains. Even a person of only slight imagination must be overwhelmed with this mighty work of nature, and must stretch both emotion and intellect to take in its magnitude.

Yet, flying over the canyonlands is like flying over the sea. As breathtaking as it is, there is no real depth perception and certainly no tactile sensation. If one desires really intimately to know the canyonlands, one must get up close, eyeball to formation wall; feel underfoot their dangerous, crumbling soils; sweat the summer heat; deal with grass burrs, mesquite thorns, the threatening ruggedness, and, above all, the intense thirst of semiarid landforms. Or, by contrast, one must shudder a bit when the vaporous ambience of a cold, foggy morning raises the specter of people and events long past. In other words, one must start, not as if looking at the sea, but, to borrow a phrase from Rick Bass, from "where the sea used to be." For an understanding of the canyonlands, let us look briefly at the geologic history of Palo Duro Canyon State Park as a case in point.

Some 230 to 280 million years ago, in the Permian period, a shallow sea covered much of present northwest Texas, laying down the characteristically reddish Quartermaster Formation, known commonly as the Permian Red Beds, the lowest, oldest exposed formation in the Park. Through subsequent millennia, alternating geologic forces of riverine de-

posit, erosion, and redeposit through the Triassic, Tertiary, and Quaternary periods built the strata which one day would become Palo Duro Canyon State Park's varicolored walls and formations of gray, yellow, maroon, lavender, and orange, shown most conspicuously in the lovely "Spanish Skirts."

Atop this layer cake of colorful strata lies the famed Ogallala Formation, laid down in relatively recent geologic time as the Rocky Mountains were uplifted and eroded by gigantic streams. As the streams flowed eastward, they deposited their burden as the final layer holding the Ogallala aquifer, upon which all High Plains life ultimately depends.

Although the formations visible in the canyonlands are old, Palo Duro Canyon itself is youthful, only about a million or so years old. Prairie Dog Town Fork of the Red River began eroding headward into the High Plains during the Pleistocene epoch and played a significant role in creating the canyon by typical riverine erosion. A process called "piping," however, is the dominant erosional force in creating the canyon. Piping occurs when water percolates downward through unconsolidated material and undercuts the softer strata lying under the hard caprock of the Ogallala and Trujillo formations. Rocks and soil split off and are carried downstream by Prairie Dog Town Fork. Thus the canyon widens and deepens into the surrounding uplands. The result of this lengthy, complex interplay of earth-shaping events evokes wonder and joy among persons possessing even a modicum of sensitivity, and inspires those of artistic bent,

whether of brush and palette or camera, to reach into the depths of their talent to produce images worthy of the subject.

In the year 2001, when it is our turn to be moved by the canyonlands' beauty and the artistic expression it inspires, who can help wondering how those who came centuries earlier experienced the canyons and expressed their emotive response? Twelve to fourteen thousand years ago, the people we know as Clovis and Folsom arrived in the southern Great Plains, and some surely found homes among the canyons. Because their archaeological sites have been only lightly explored, we know relatively little of these first residents, although obviously they lived off the land and took their sustenance from native vegetation and game, including giant bison and mammoths. By the standards of early man, Clovis and Folsom people probably lived fairly well and their delicately fluted projectile points evidence remarkable flint-knapping artistry.

Over the following millennia, the native population ebbed and flowed with vagaries of climate. Severe drought drove people away for extended periods. As climate moderated, new groups entered and adapted, and their rock art indicates a significant degree of cultural attainment.

When first observed by Europeans in 1541, natives of the plains and canyons had invented the bow and arrow, and followed on foot the herds of bison which were the basis of their subsistence, but the canyonlands had an important place in nomadic plains life. Wood, water, game, and edible vegetation remained abundant; in the colder months, the canyons provided sheltered campgrounds. When challenged by white people

for possession of their land, Indian tribes took refuge within canyon walls so remote, so forbidding, they felt their white enemies would never find them. That sense of security turned out to be false, and the handwriting appeared on the wall, faintly, before the midpoint of the sixteenth century. Obviously the Native Americans did not read it, but what people could have? By the same token, the writers had little, if any, understanding of what they had done.

Palo Duro, Tule, Llano Estacado, Tierra Blanca. Such terms, so identified with the canyonlands, resonate richly and powerfully with associations to Hispanic history beginning over four and a half centuries ago. In 1541, the great *entrada* of Francisco Vasquez de Coronado crossed the High Plains (or *Llano Estacado*, as the area became known to the Spanish explorers) amid confusion and wonder at its apparent endlessness. Canyons on the eastern escarpment sheltered and supported the expedition—a fact proven by recent archaeological excavation—and served as a base for launching the explorer's picked-man thrust to Quivira. The native peoples Coronado observed in 1541 are generally believed to have been ancestors of the historic Apaches who dominated the southern Great Plains until driven away by invading Comanches in the early eighteenth century. By that time, horses had become as important as the bison, and horse nomadism was the cultural order of the day.

Hispanic people, for various reasons, visited the whole of West Texas during the sixteenth and seventeenth centuries, and, a century before the Declaration of Independence, had named every significant point

in West Texas. Thus, the Spanish authorities were well prepared when, in the late eighteenth and early nineteenth centuries, they resolved to open direct communication between outposts on the eastern and western borders of their inland empire, especially between San Antonio and Santa Fe, and to make friends with the Comanches who dominated the vast territory in between. Such an explorer was the sixty-nine-year-old Captain Francisco Amangual, who, in late March 1808, led a force of two hundred men out of San Antonio. On May 12 the expedition approached the Llano Estacado. They marched northward across its eastern flank, crossing the canyons with difficulty. Amangual's command experienced all the hardships of West Texas travel: rugged terrain, high winds, thunderstorms, tornadoes, and, as always, scarcity of potable water—but they knew where to look for water. They found it in the upper reaches of the canyons, and then turned west along Tierra Blanca Creek to reach Santa Fe. Captain Amangual succeeded through his skill as a commanding officer and wilderness traveler, and by clever use of more-or-less friendly Comanche guides—through whose good offices the Spaniards' *cavallada* stampeded almost nightly.

On June 1, Amangual met a party of hunters who came from Santa Fe to hunt the bison of the plains. For many years, New Mexican bison hunters, *ceboleros,* supplied meat, leather, robes, and suet to the Rio Grande settlements and pueblos through their periodic forays onto the buffalo plains. Though it had its dangers, *cebolero*-style hunting, on horseback with lance, was undertaken with lighthearted, wild enthusiasm, the

thrill of the hunt being as much its object as the quarry. Through such venturesome enterprises even the most humble New Mexicans learned the ways of the plains and canyonlands, how to cope with their dangers and survive, perhaps even prosper. *Ceboleros* often turned their plains lore to account and became traders with the Indians of the plains—comancheros. Trade between the settled people of the New Mexican river valleys and the nomads of the plains existed long before Europeans entered the Southwest; they traded food and utilitarian items such as pottery and baskets in exchange for meat, hides, and buffalo robes. By roughly 1850, the comancheros expanded the trade by introducing industrial goods such as guns, and fermented ones such as whiskey, which they traded for stolen horses and mules. The system was to meet Plains Indians at secluded places beyond the reach of any governmental authority. What better place could be imagined than the isolated recesses of Palo Duro or Tule canyons? Few records were kept, but oral tradition (perhaps reinforced by experience) kept alive, from generation to generation, the knowledge and lore of the Llano Estacado and its canyons.

If Anglo-American settlers had shared their Hispanic predecessors' knowledge, it would have saved them a lot of grief. The newborn Republic of Texas claimed its western boundary at the Rio Grande from mouth to source including Santa Fe, the western end of the profit-laden Santa Fe Trail. In 1841, President Mirabeau B. Lamar instigated the Texas Santa Fe Expedition to occupy the claimed portion of New Mexico, establish the Republic's authority there, and divert Santa Fe trade riches from

the United States to Texas. Not a single member of that expedition knew the territory, and no cultural heritage prepared the Texans to cope with, for them, the ominous environment of West Texas. The Texan Santa Fe Pioneers reached the base of the High Plains at Quitaque Canyon on August 30 in disarray and desperation—a far cry from the condition of Amangual's men thirty-three years earlier. Among the hapless Texans was George Wilkins Kendall of the New Orleans *Picayune,* who, so to speak, went along for the ride. With an advance party, Kendall crossed Tule Canyon in early September and described the Tule in precise detail as a good reporter should, but as a personal reaction seems to have regarded Tule Canyon as another burden to be borne by men already bearing too many.

Eleven years after the Texan Santa Fe misadventure, the Palo Duro–Tule complex evoked an opposite reaction from Captain Randolph B. Marcy of the Fifth Infantry. Marcy was a seasoned southwestern explorer. As compared to the Texan Santa Fe Pioneers, in short, he knew what he was doing—and hired savvy Indian guides.

Fairly early in the nineteenth century, knowledgeable people knew that the major Texas streams headed along the High Plains' eastern escarpment, but the exact location of the headwaters of Red River of Louisiana was of special concern. In 1852, Marcy's aggressive enthusiasm for exploration placed him in command of an expedition to settle the question by ascending the Red from a point downstream. In late June, Marcy's command camped at the base of the High Plains, and, with a detachment of select men, Marcy continued up Prairie Dog Town Fork, the main

headstream of Red River. Despite finding no potable water for several days, the Captain became more and more enthralled with the castle- and fortress-like appearance of the canyon and its richly diverse wildlife. Perhaps the Captain, obviously in his element, was too impressed, because his florid language compromises the effectiveness of his report.

Marcy identified a great spring flowing from the base of a cliff as the main headspring of Red River, but so vaguely as to confuse its location thoroughly and create usually friendly, but often animated, controversy among latter-day scholars. Only in a general way, then, did Marcy "prove" that the Red River headed in the canyons of the High Plains. The area remained inexactly known for another quarter century until, in 1876, First Lieutenant Ernest Howard Ruffner conducted a stadia line survey of the upper Red, the Palo Duro–Tule Canyon complex, and their contiguous uplands.

Fortunately, Marcy's enthusiasm and Ruffner's professionalism live on in Wyman Meinzer. A few hours spent with him on a photographic expedition leaves one with a feeling of having shared the company of a man at ease with his time and place, but on another level, really living out of season. Born and reared in the rugged, unforgiving ranchlands of Knox County, Texas, he grew to manhood knowing, and taking as normal, a life close to the ground. Born a century earlier, he might have trailed longhorns to Abilene or hunted buffalo in his home range; a century and a half earlier he might have been found among the beaver men of the Rockies; two centuries earlier Meinzer might have been among the over-mountain

men who faced westward, but turned back east to defend home and family at King's Mountain.

Among such men, Meinzer would have found a place, although different from his fellows in a fortunate respect: he is a born hunter and naturalist, instinctively investigating and learning on a level beyond essential survival skills. In time, he put aside rifle in favor of camera, which he turned to subjects largely neglected by other fine photographers: roadrunners, coyotes, quail, and playas.

Now he directs his lens to the canyons of the High Plains, including privately owned and little-known sites in Palo Duro Canyon and Caprock Canyon State Parks. That he is Texas's official state photographer certainly unlocks gates to private lands that remain locked to others, and his respect for landowners' wishes keeps them unlocked. Those others might not be so excluded had some not betrayed confidences, intruded thoughtlessly, or invoked the lame rubric that explaining is easier than asking.

While it is true that Meinzer has an eye for subjects not much noticed by others, it is equally true that his energetic interests extend to the more obviously beautiful; readers of this book cannot but be moved by his capture of the canyons' visual impact.

As noted earlier, the canyonlands ecosystem remains dynamic in slow, ongoing change, through its own timeless processes or, more rapidly and distortedly, through the impact of people. Visitors to Palo Duro Canyon State Park in 2001 see canyonscapes significantly altered from those

seen and recorded by early twentieth-century photographers whose images provide a baseline for present and future comparison. So, as well as enriching current cultural interests, *Canyons of the Texas High Plains* serves the purposes of long-term scholarship. The sites of these photographs are carefully documented and will be preserved. Fifty years from now—or one hundred or two hundred—camera-wielding naturalists and scientists can return to the scenes preserved through Wyman Meinzer's camera and have precisely identifiable sites for repeat photography, recording and comparing the transformation of the canyonlands—transformation for good or ill; slow changes through nature's ancient sculpting ways respected by the human community, or rapid distortion from disrespectful treatment by humans increasingly alienated from life close to the ground.

Alienated from life lived close to the ground. That includes virtually all of us. We need these images—lest we become soul-dead—for our pleasure in their beauty and for sharpening our sense of privilege to be the stewards of the canyonlands in the years granted to us.

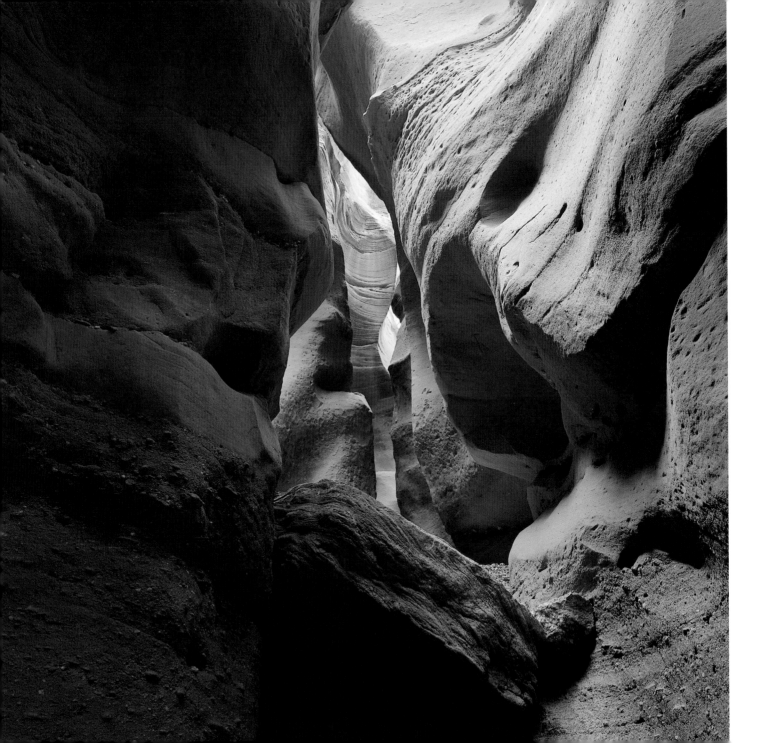

—FORMATIONS—

Los Lingos narrows,
Briscoe County, a major
site of the comanchero trade
Hasselblad 500CM; Distagon 50mm f/4.0;
Fujichrome Velvia

13

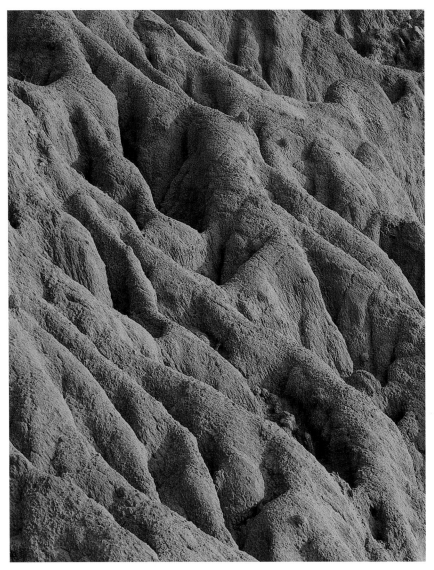

Rain-sculpted sandstone,
lower Palo Duro Canyon,
Armstrong County
Hasselblad 501CM; Zeiss Sonnar T*
150mm f/4.0; Fujichrome Provia 100

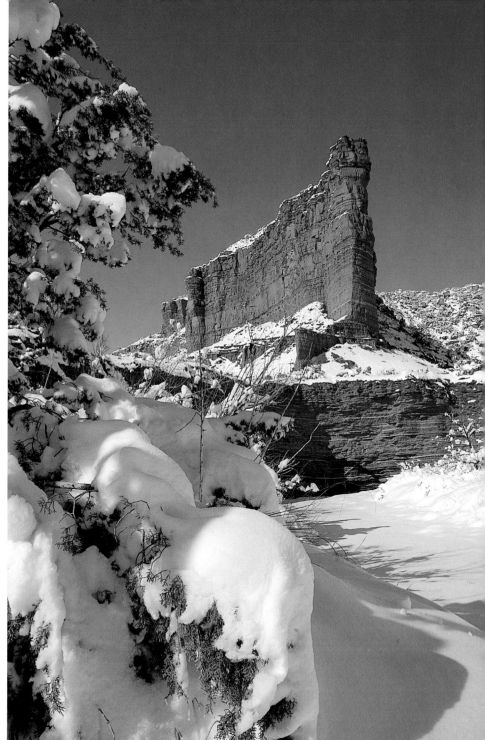

Cathedral of the Canyons
along Highway 207,
Tule Canyon
Canon F1 with AE motor
drive; Canon 20–35mm;
Fujichrome Velvia

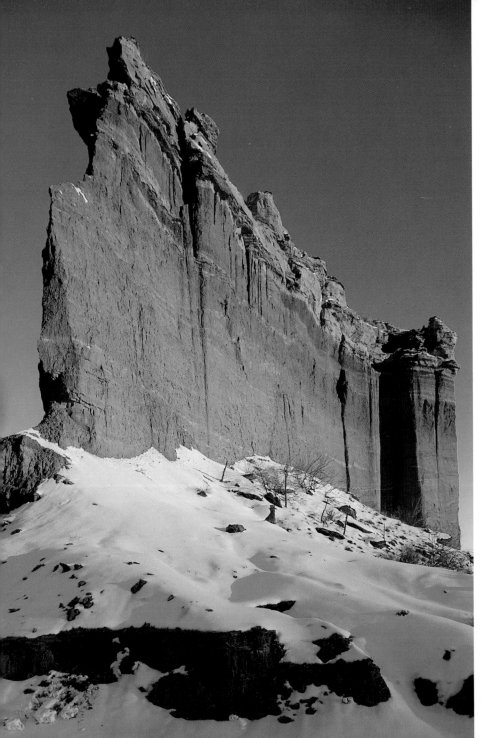

The Butte along
Highway 207, Tule Canyon.
"Glorious and majestic
are his deeds. . . . He has caused
his wonders to be remembered."
Psalm 111.
Canon EOS-1N; Canon 24mm Tilt-Shift f/3.5;
Fujichrome Velvia

Tule narrows, Briscoe County.
"Immense walls, columns, and . . .
what appeared to be arches,
were seen standing, modelled
by the wear of water. . . . "
George W. Kendall, 1841.
Hasselblad 500CM; Planar 80mm f/2.8;
Fujichrome Velvia

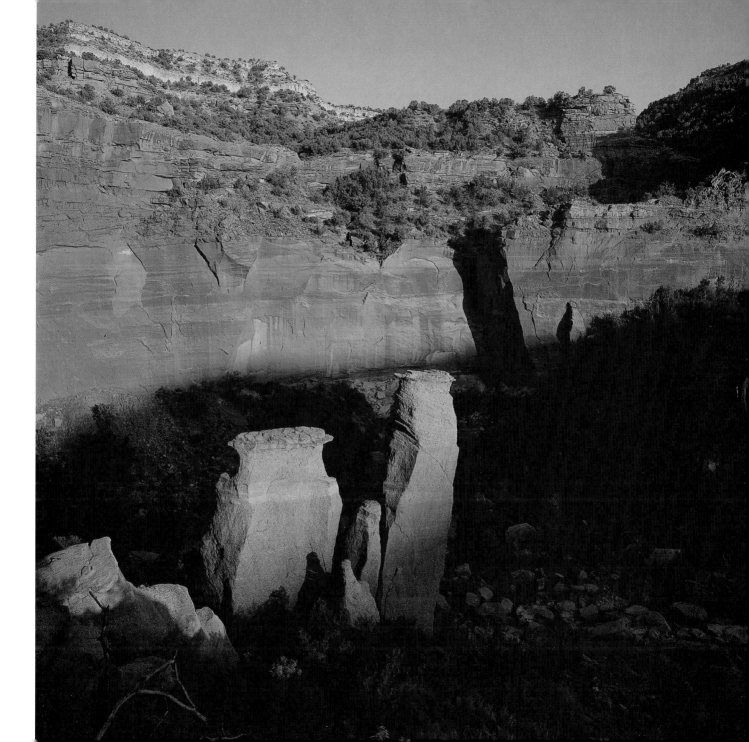

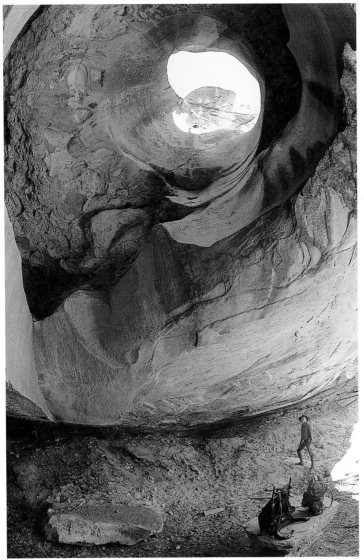

Texas's largest natural
arch, upper Palo Duro
Canyon, Randall County
Canon F-1 with AE motor drive;
Canon 15mm Fisheye 2.8;
Fujichrome Velvia

Snow cover in Palo Duro
Canyon State Park
Canon F1 with AE motor drive;
Canon 20-35mm f/3.5L;
Fujichrome Velvia

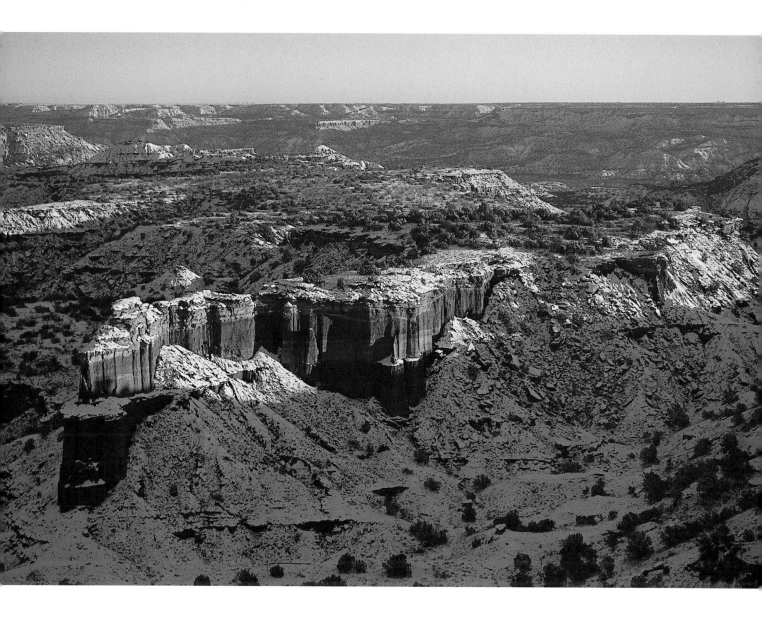

Caprock Canyon State Park,
South Prong Canyon.
"A sickly sensation of dizziness
was felt by all as we looked down,
as it were, into the very depths of the
earth." George W. Kendall, 1841
Hasselblad 500CM; Zeiss Planar T* 80mm;
Fujichrome Velvia

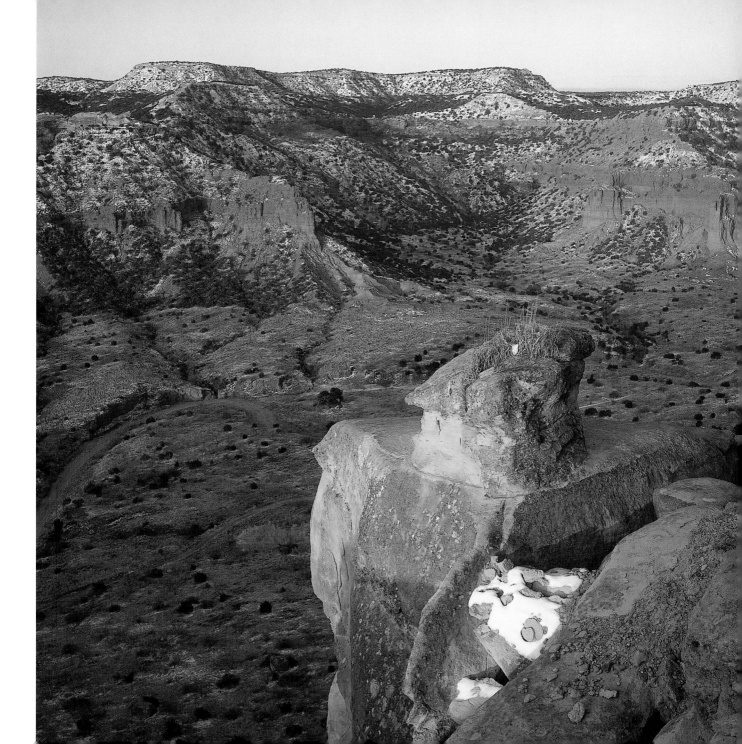

Sandstone formation,
South Cita Canyon,
Randall County
Hasselblad 501CM; Distagon
50mm f/4.0; Fujichrome Velvia

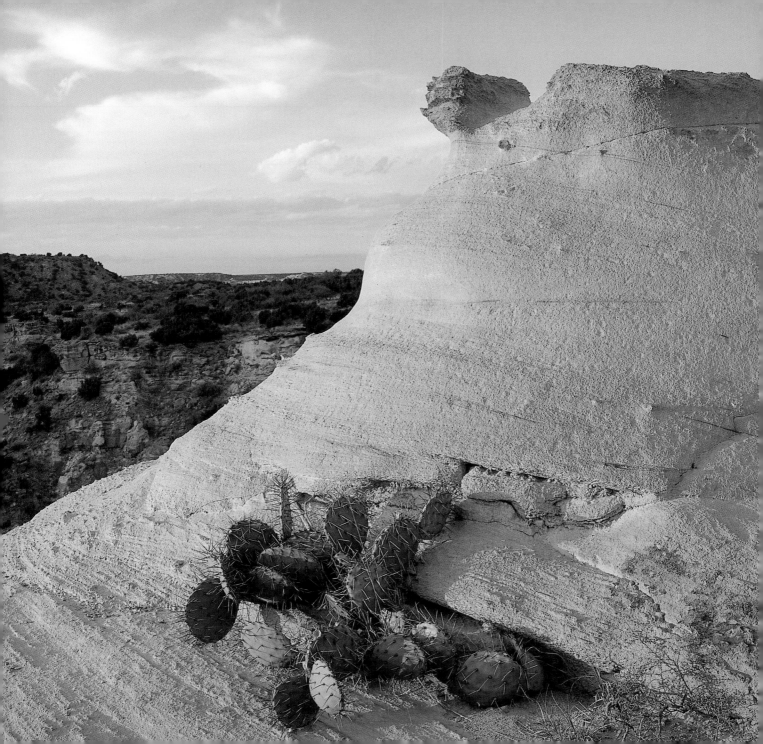

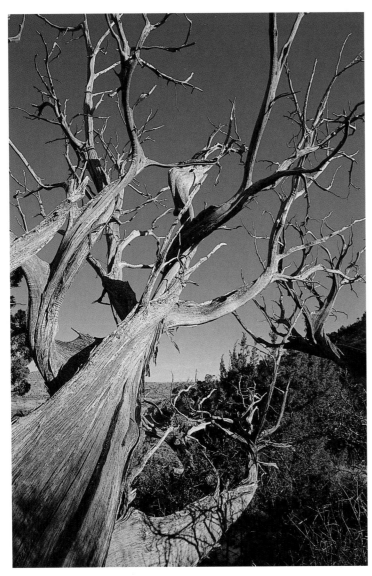

Palo Duro—hardwood—
whence the canyon gets
its name.
Canon EOS-1N; Canon 24mm
Tilt-Shift f/3.5; Fujichrome Velvia

Ancient juniper—
palo duro—Palo Duro
Canyon State Park
Hasselblad 500CM; Distagon
50mm f/4.0; Fujichrome Velvia

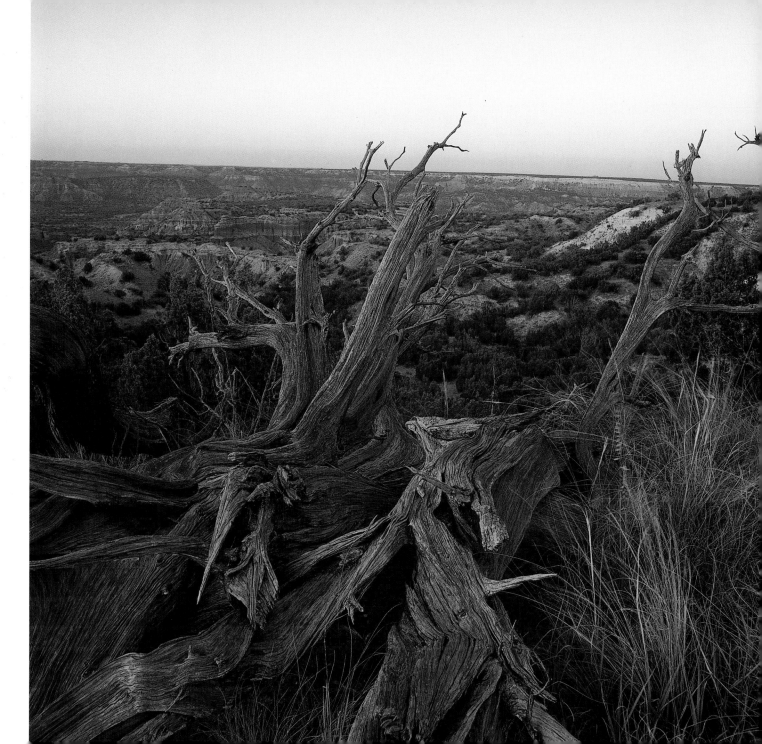

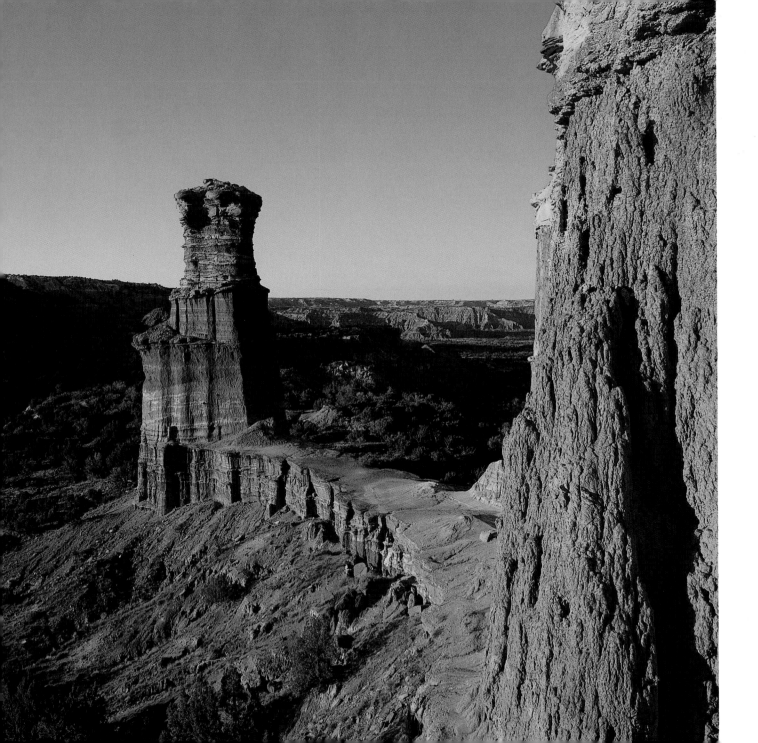

The Lighthouse,
symbol of Palo Duro
Canyon State Park,
beckons hikers.
Hasselblad 500CM; Distagon
50mm f/4.0; Fujichrome Velvia

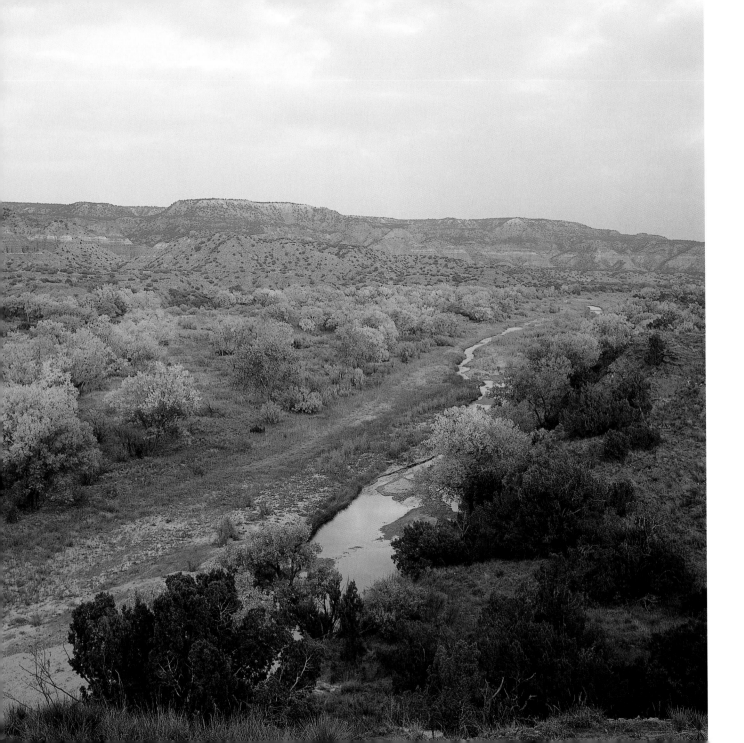

—WATER—

Autumn along Prairie
Dog Town Fork of Red River,
Palo Duro Canyon
Hasselblad 500CM; Zeiss Planar T*
80mm f/2.8; Fujichrome Velvia

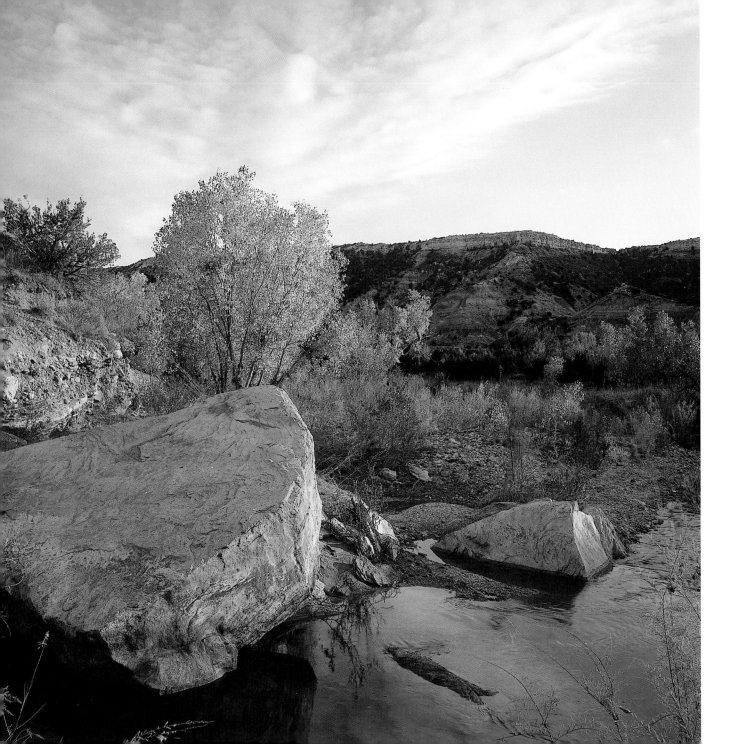

Autumn foliage,
Palo Duro Canyon
State Park
Hasselblad 500CM;
Distagon 50mm f/4.0;
Fujichrome Velvia

Cita Creek,
South Cita Canyon,
Randall County
Hasselblad 501CM;
Distagon 50mm f/4.0;
Fujichrome Provia 100

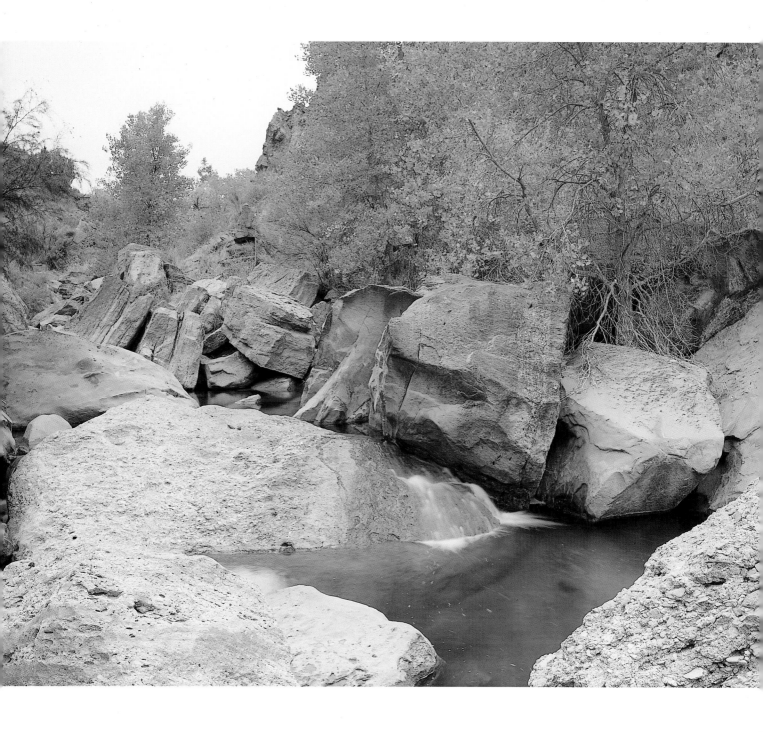

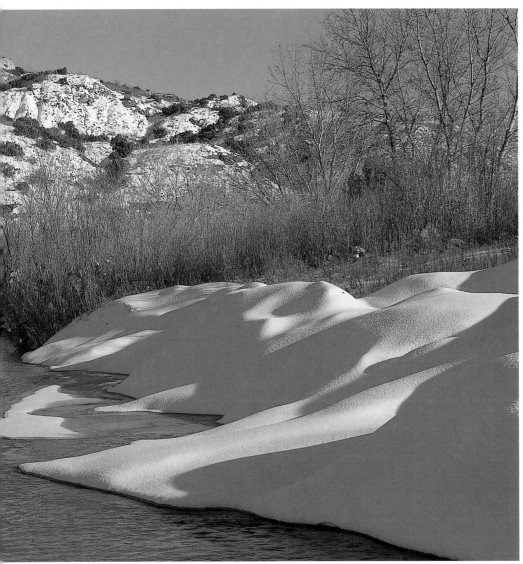

Snow cover along
Red River, Palo Duro
Canyon State Park
Hasselblad 501CM; Zeiss Sonnar T*
150mm; Fujichrome Provia 100

Tule Canyon, Randall
County, where the "piping"
process goes on—and on.
"On beholding this minute
rivulet . . . it is difficult to
realize that it forms the germ
of one of the largest and
most important rivers in
America." Randolph B.
Marcy, 1852.
Hasselblad 500CM; Zeiss Planar T*
80mm; Fujichrome 50

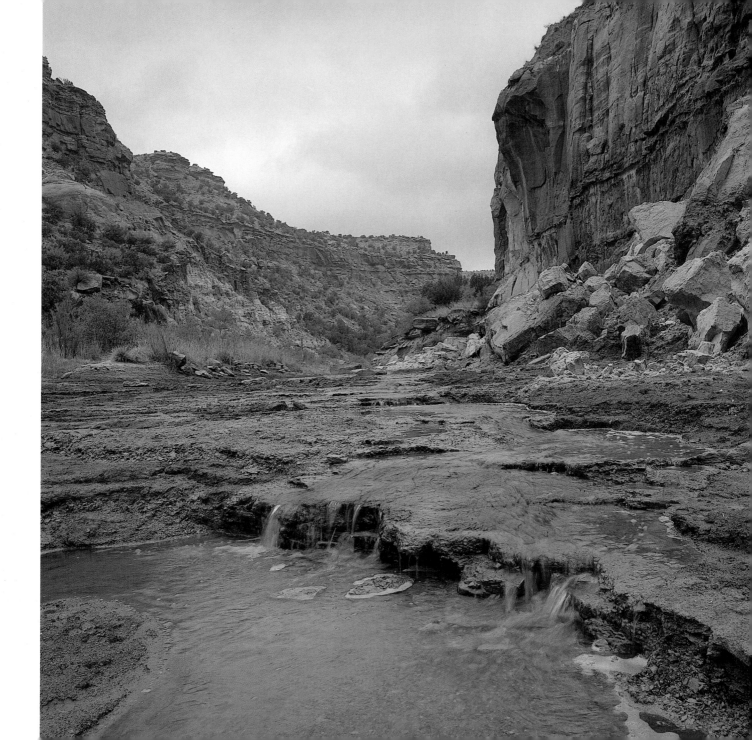

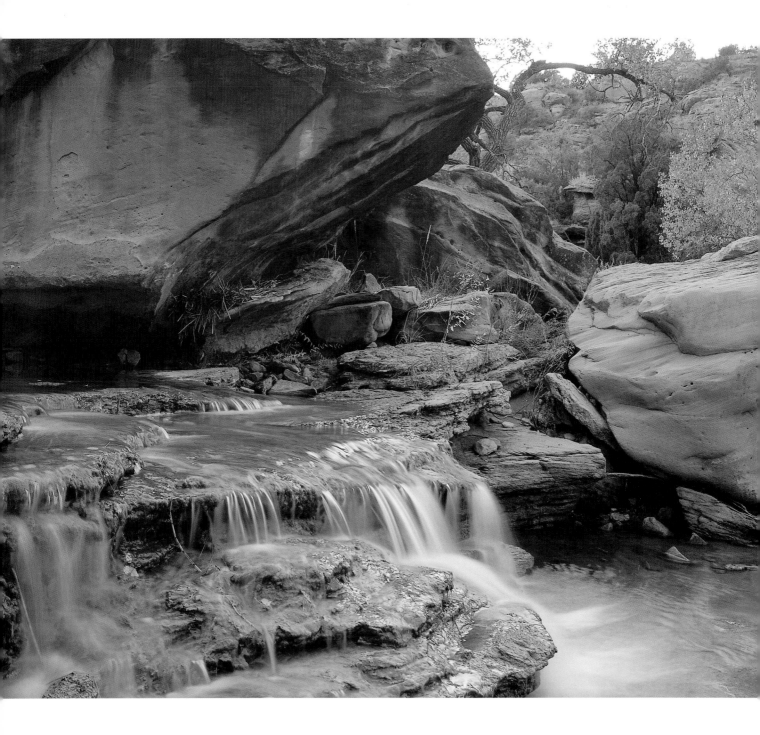

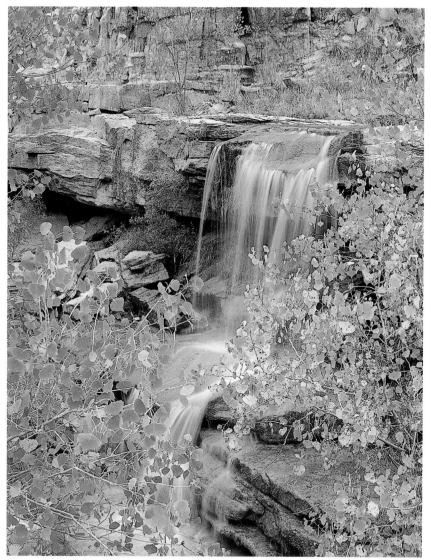

Rivulet tributary
to Red River, South Cita
Canyon, Randall County
Hasselblad 501CM; Distagon
50mm f/4.0; Fujichrome Provia 100

Waterfall in
South Cita Canyon,
Randall County
Hasselblad 501CM; Zeiss Planar T*
80mm f/2.8; Fujichrome Provia 100

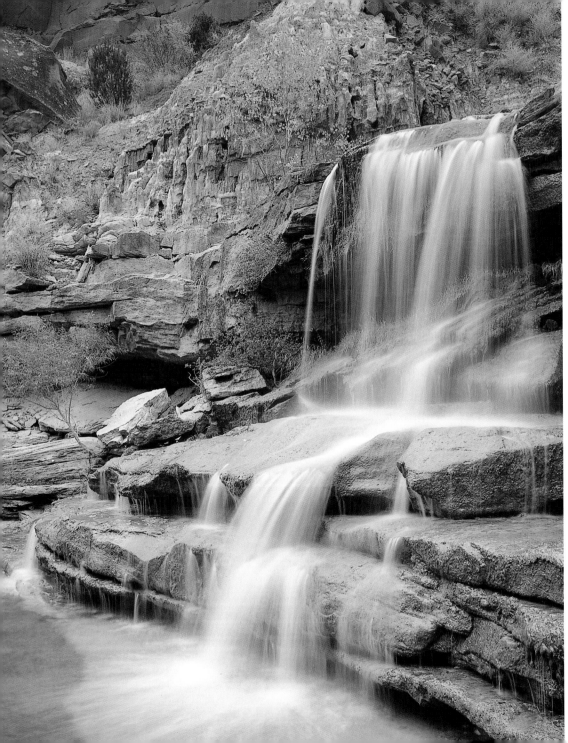

Waterfall in
South Cita Canyon,
Randall County
Hasselblad 501CM;
Zeiss Planar T* 80mm
f/2.8; Fujichrome
Provia 100

Evening sun
on Spanish Skirts,
Palo Duro Canyon
State Park.
"Then God said 'Let
there be light . . . to
give light on the
earth.'" Genesis I
Hasselblad 500CM;
Zeiss Planar T* 80mm
f/2.8; Fujichrome
Velvia

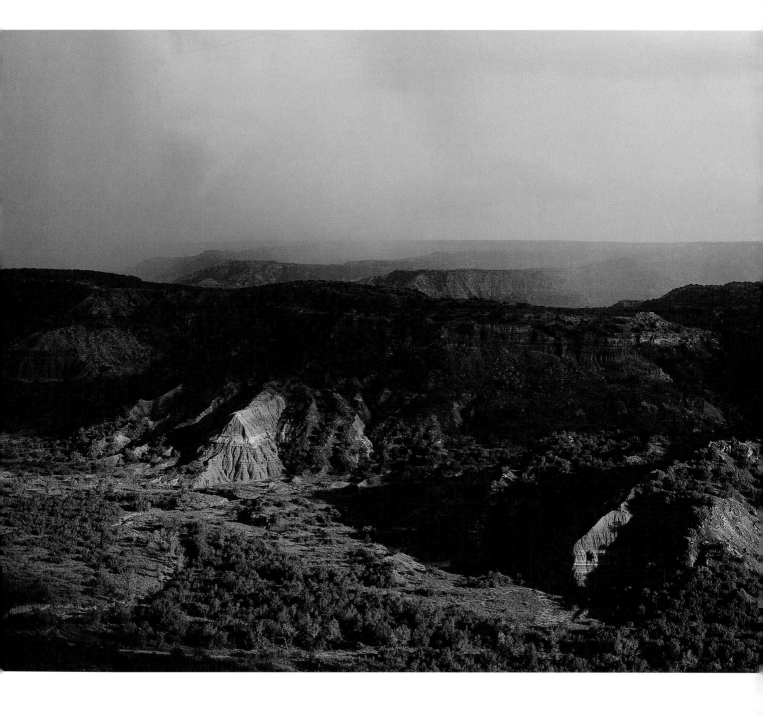

Summer storm over Palo Duro Canyon State Park. "Deafening peals of thunder seemed rising from the very bowels of the earth. . . . The yawning abyss appeared to be a workshop for the manufacture of the storm. . . .
George W. Kendall, 1841
Hasselblad 500CM; Zeiss Sonnar T* 150mm ƒ/4.0; Fujichrome Provia 100

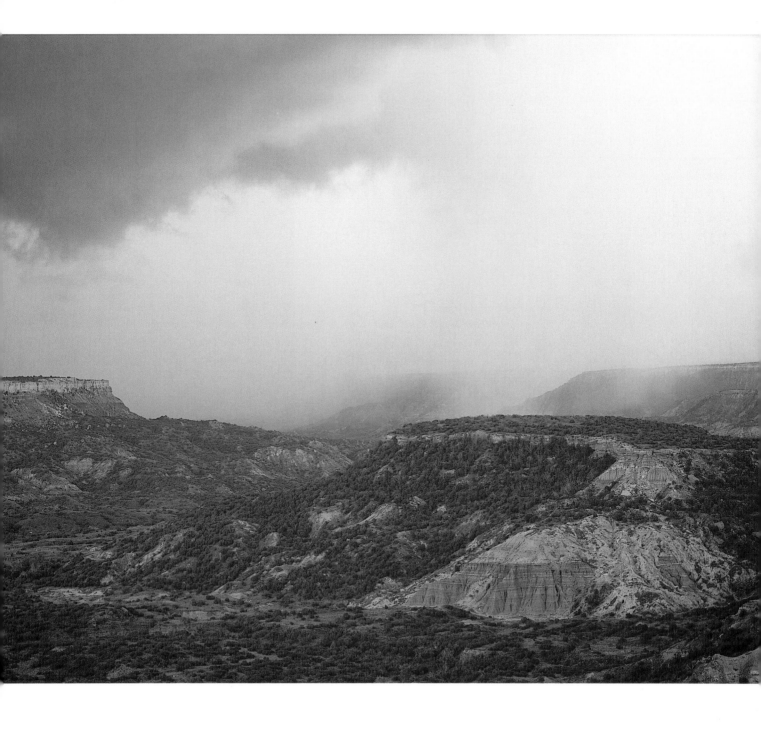

P alo Duro Canyon.
"Of old hast Thou founded
the earth, and the heavens
are the work of Thy hands."
Psalm 102
Canon F1; Canon 20–35mm f/3.5;
Fujichrome Velvia

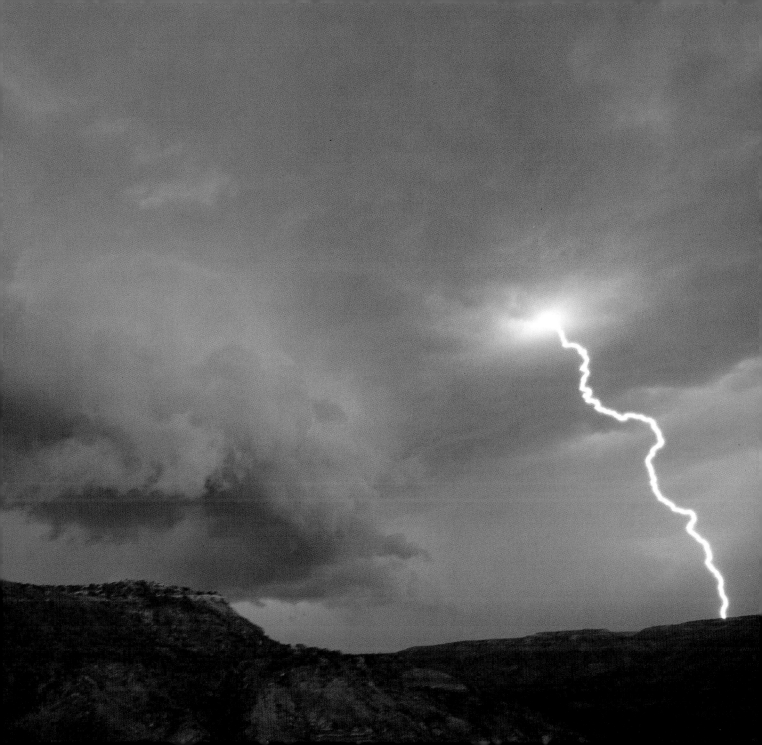

Flash flood in Palo Duro
Canyon near head of
Prairie Dog Town Fork,
Randall County
Canon EOS-1N; Canon 24mm
Tilt-Shift f/3.5; Fujichrome Velvia

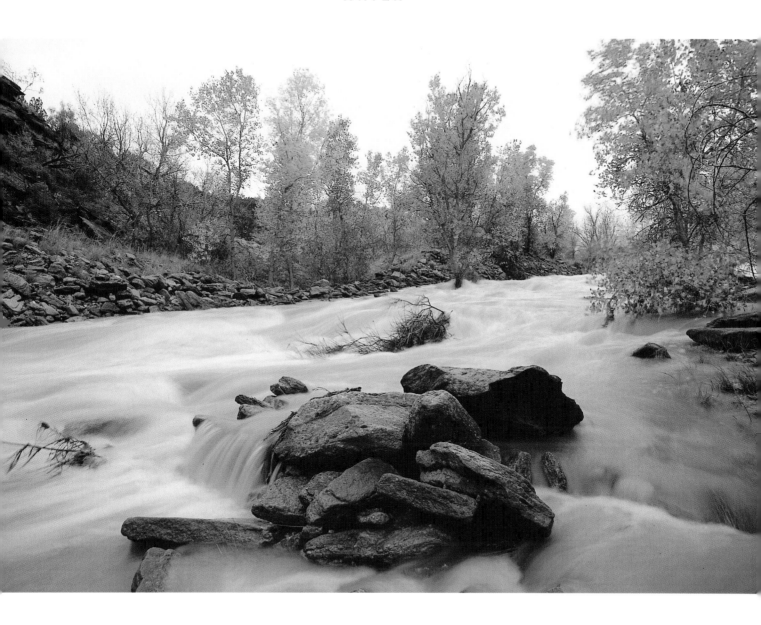

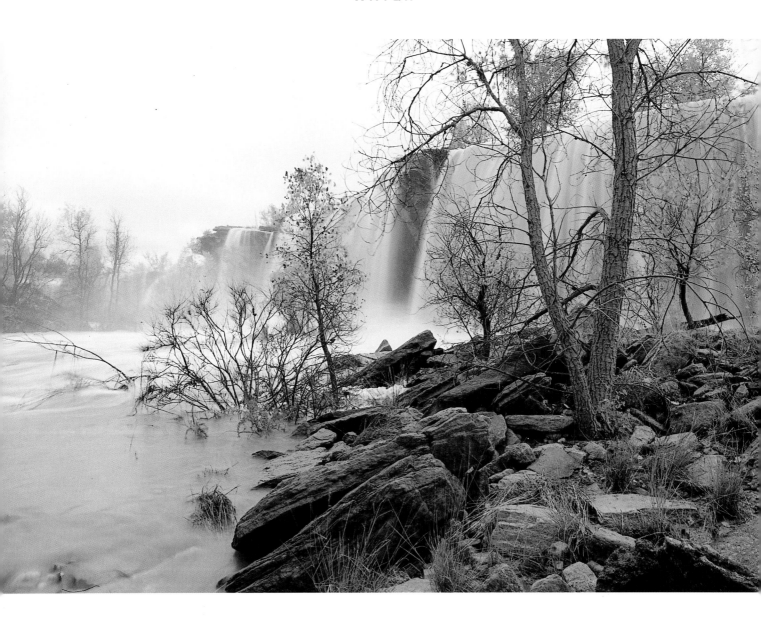

Flash flood waterfall,
Prairie Dog Town Fork,
Palo Duro Canyon,
Randall County
Canon EOS-1N; Canon 24mm
Tilt-Shift f/3.5; Fujichrome Velvia

Rainbow over Fortress Cliff,
Palo Duro Canyon State Park.
"O Lord . . . how majestic
is Thy name in all the earth,
who hast displayed Thy splendor
above the heavens." Psalm 8
Canon F1 with AE motor drive;
Canon 35-105mm; Fujichrome Velvia

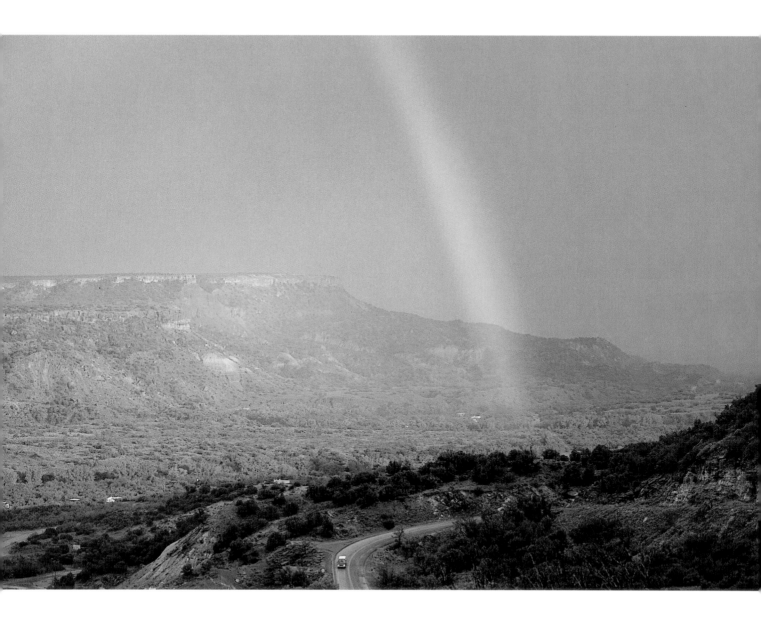

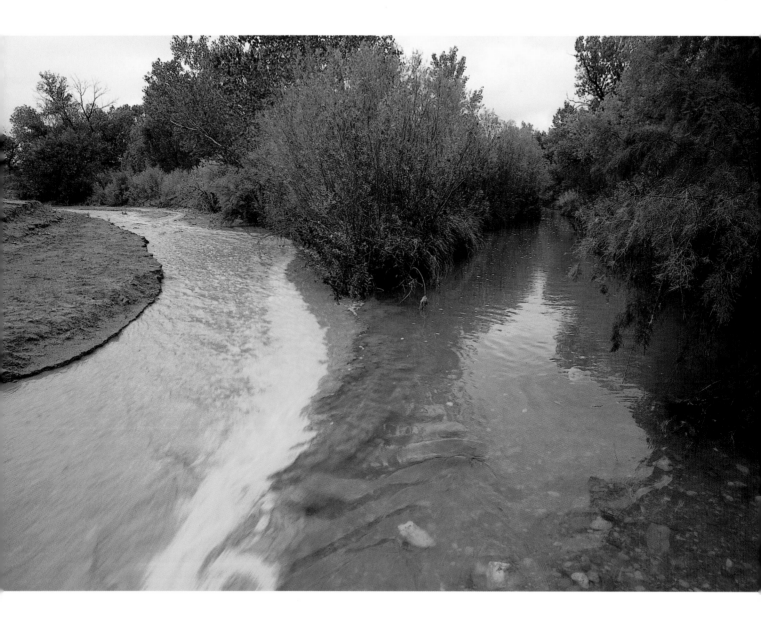

Silt sediment flow
after cloudburst—why
the River is Red. Prairie
Dog Town Fork of Red River,
Palo Duro Canyon State Park
Canon F1 with AE motor drive;
Canon 20-25mm f/3.5L; Fujichrome Velvia

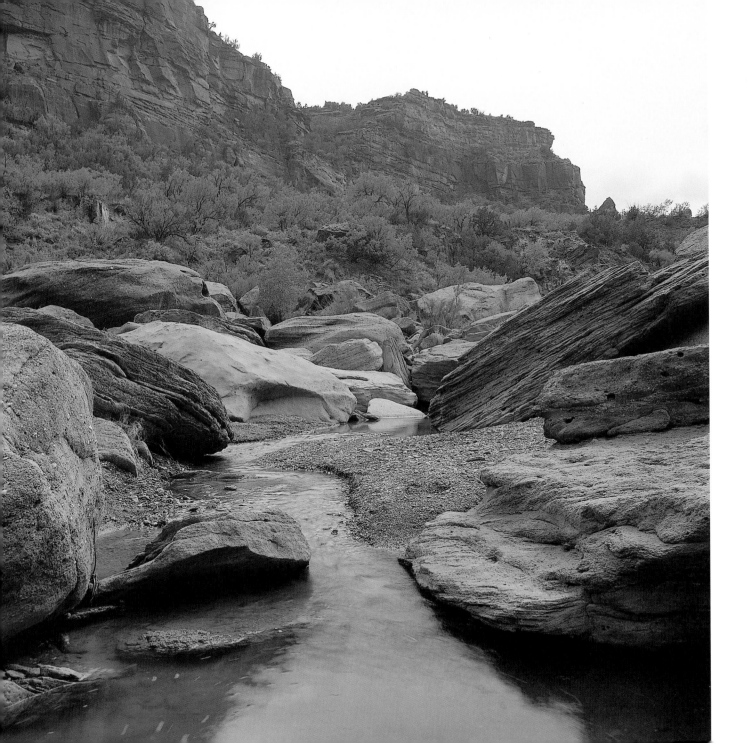

—Habitat—

Tule Canyon Narrows,
Briscoe County. "I took my
siesta in the Rio del Tule;
it is permanent and has many
cottonwood trees and many reeds."
Jose Mares, August 8, 1787
Hasselblad 500CM; Distagon 50mm f/4.0;
Fujichrome Velvia

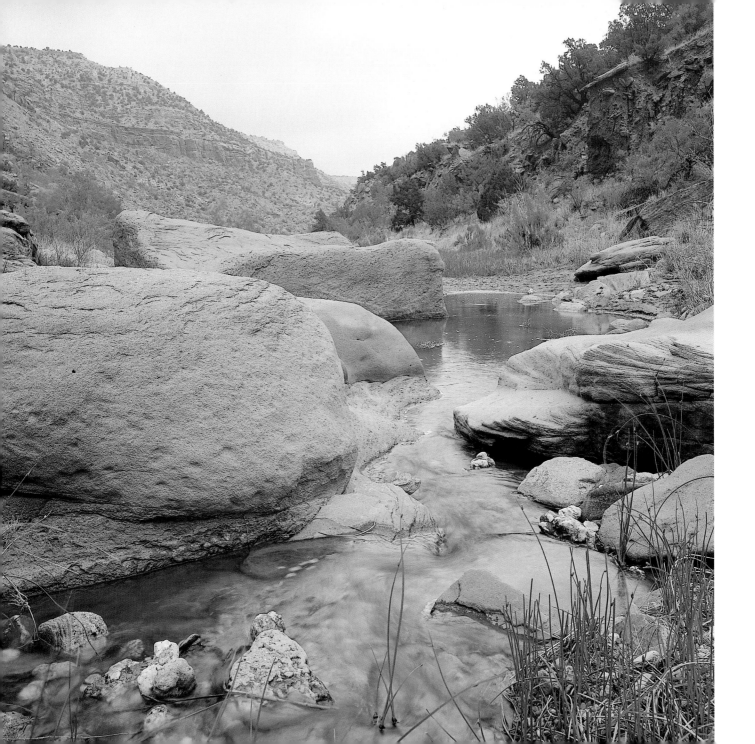

Tule Canyon watering
hole for man and wildlife,
Briscoe County
Hasselblad 501CM; Distagon
50mm f/4.0; Fujichrome Velvia

Grassland above
Cita Canyon,
Briscoe County
Hasselblad 500CM; Zeiss Sonnar T*
150mm f/4.0; Fujichrome Velvia

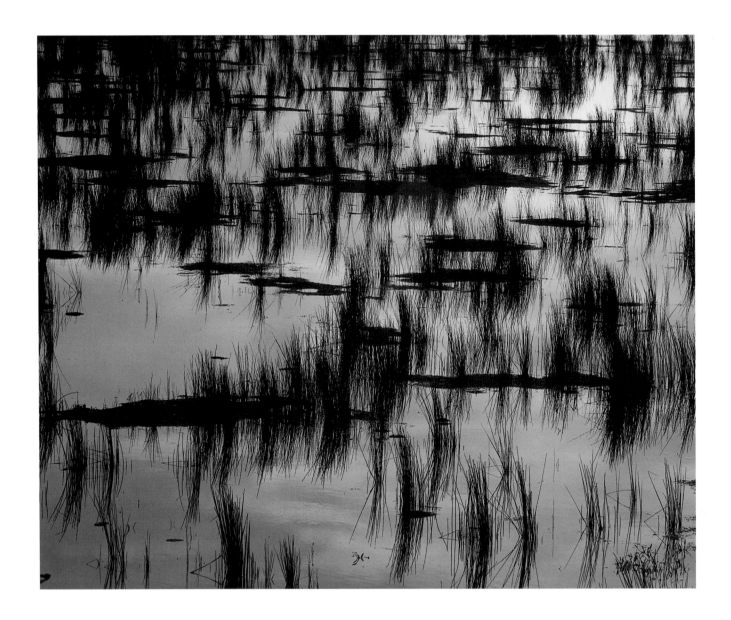

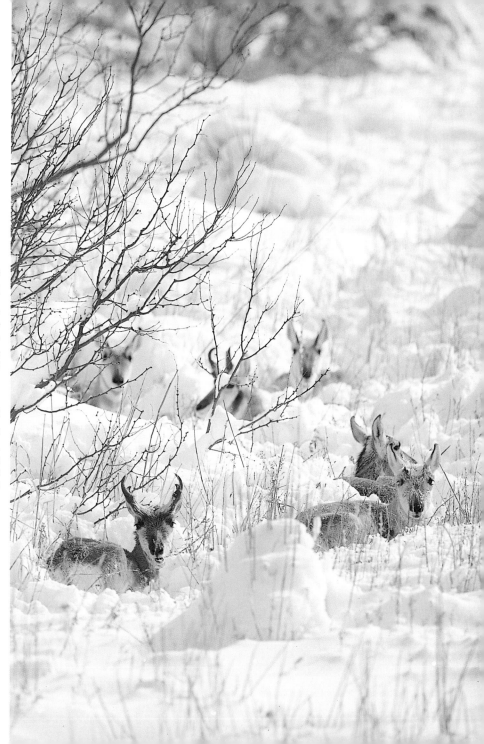

Playa above Palo Duro Canyon—a jewel of the High Plains. Armstrong County
Hasselblad 501CM; Zeiss Sonnar T*
150mm with 1.4 Hasselblad extender
f/4.0; Fujichrome Provia 100

Pronghorns at rest in snow, Caprock Canyon State Park.
Canon F1 with AE motor drive;
Canon 500mm f/4.5L;
Fujichrome Velvia

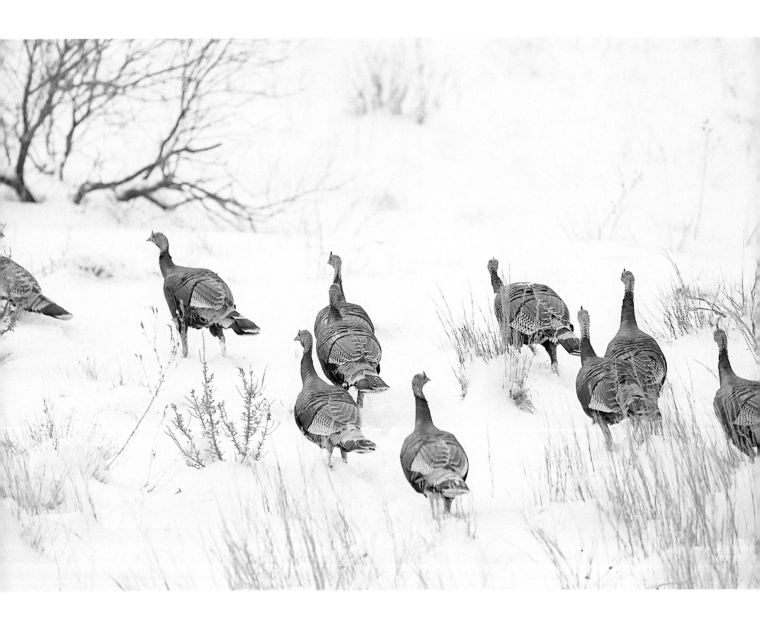

Wild turkeys
in snow cover,
Palo Duro Canyon
State Park
Canon F1 with AE
motor drive; Canon
500mm f/4.5L;
Fujichrome Velvia

Wild turkeys in Palo
Duro Canyon State Park
Canon F1 with AE motor drive;
Canon 500mm f/4.5L;
Fujichrome Velvia

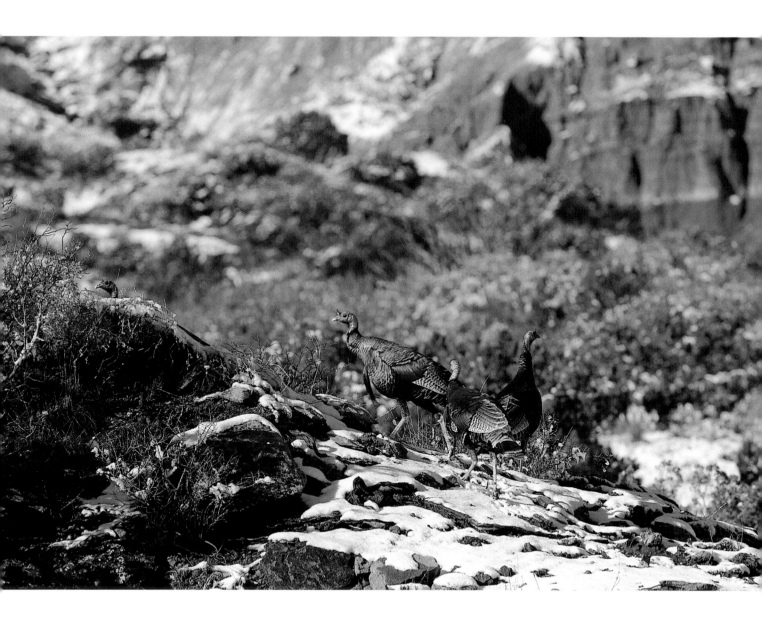

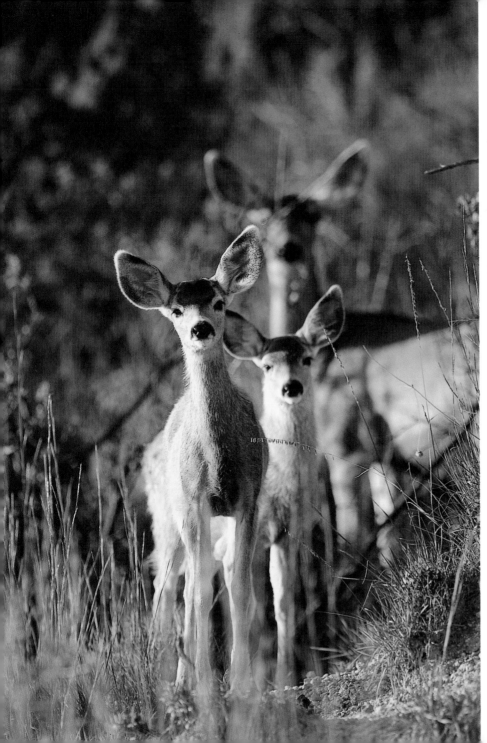

Mule deer in Cita Canyon, Randall County, survivors, along with turkeys and pronghorns, of the time when bison, bears, pumas, wolves, and elk roamed the canyonlands.
Canon F1 with AE motor drive; Canon 500mm f/4.5L; Fujichrome Velvia

Mortar holes, Palo Duro Canyon State Park, Armstrong County. Here Native Americans prepared native vegetation for immediate use or preservation.
Hasselblad Flex Body; Distagon 50mm f/4.0; Fujichrome Provia 100

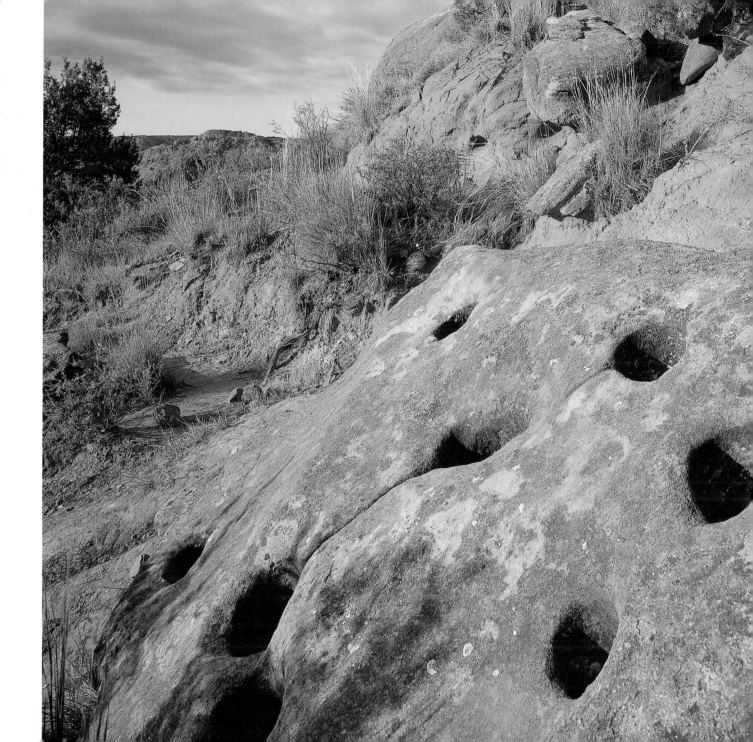

Petroglyphs, lower
Palo Duro Canyon, the
artistry of ancient citizens
of the canyons.
Hasselblad 500CM; Distagon
50mm f/4.0; Fujichrome Velvia

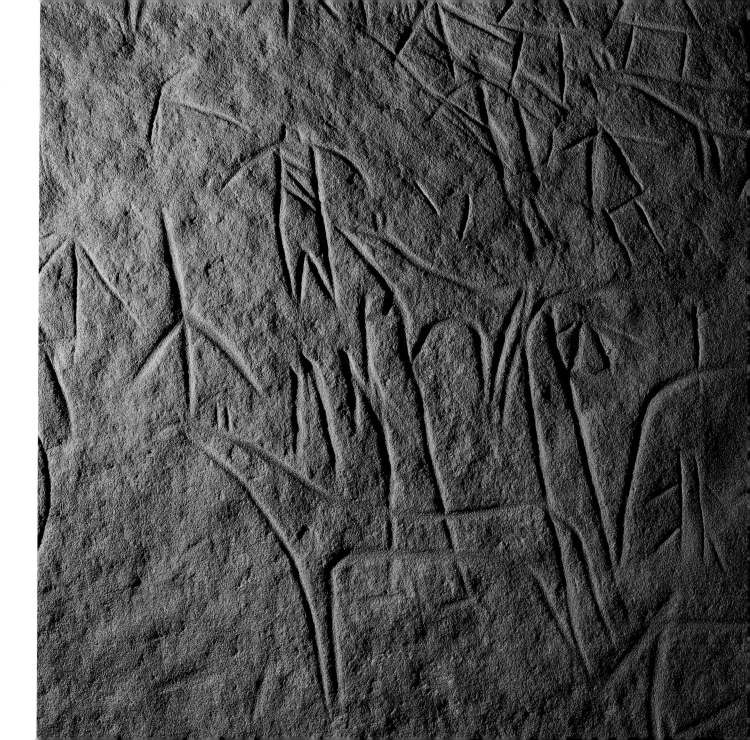

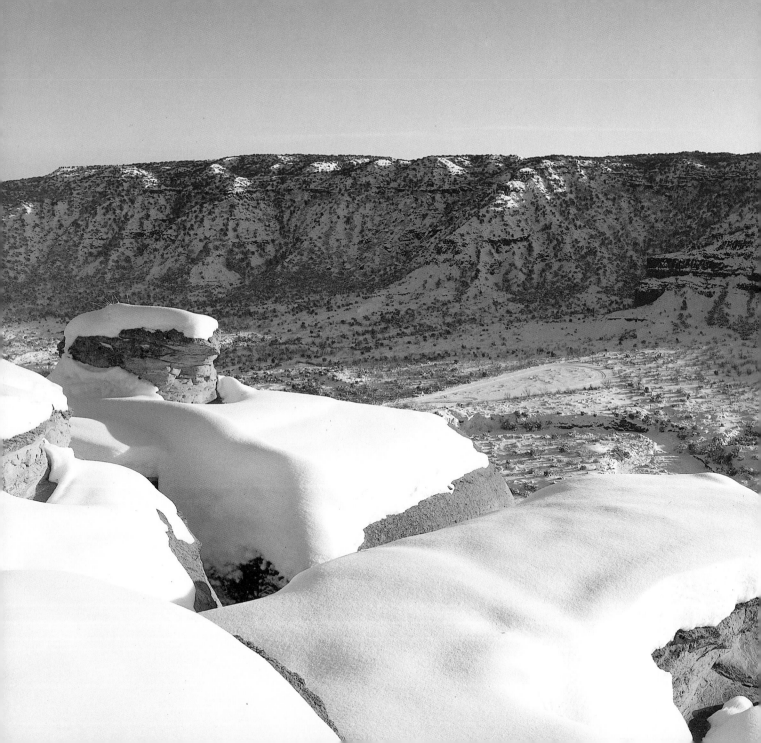

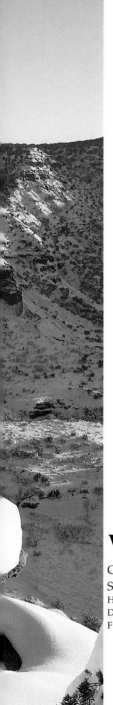

—Canyon Seasons/Flora—

Winter repose,
Caprock Canyon
State Park.
Hasselblad 500CM;
Distagon 50mm;
Fujichrome Velvia

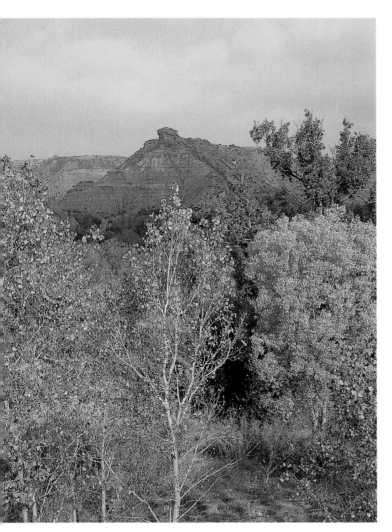
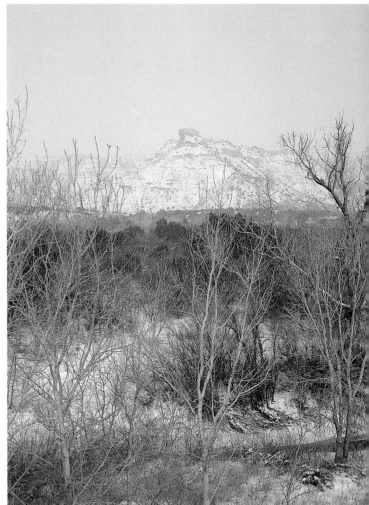

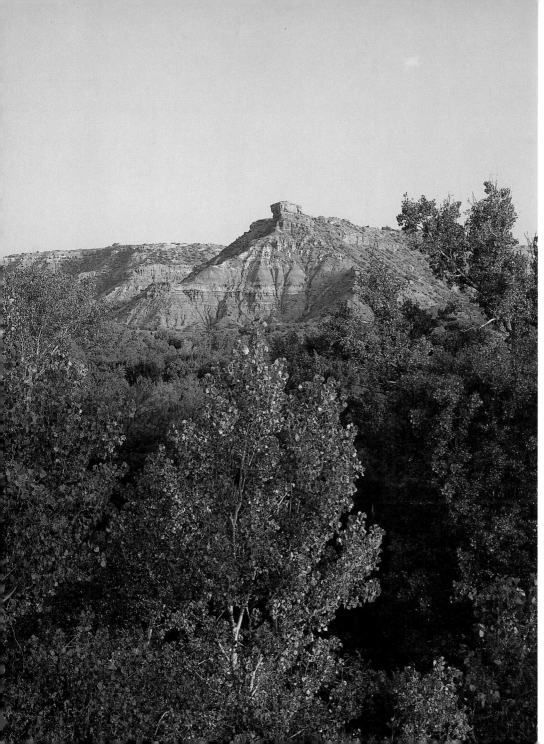

Palo Duro
Canyon State Park
in autumn gold.
Hasselblad 500CM; Zeiss
Planar T* 80mm f/2.8;
Fujichrome Velvia

Palo Duro
Canyon State Park
in winter silver.
Hasselblad 500CM; Zeiss
Planar T* 80mm f/2.8;
Fujichrome Velvia

Palo Duro
Canyon State Park
in summer green.
Hasselblad 500CM; Zeiss
Planar T* 80mm f/2.8;
Fujichrome Velvia

Tasajillo cactus,
native of the desert,
under snow—an anomaly
of the canyonlands.
Palo Duro Canyon,
Randall County
Hasselblad 500CM; Zeiss
Sonnar T* 150mm f/4.0;
Fujichrome Velvia

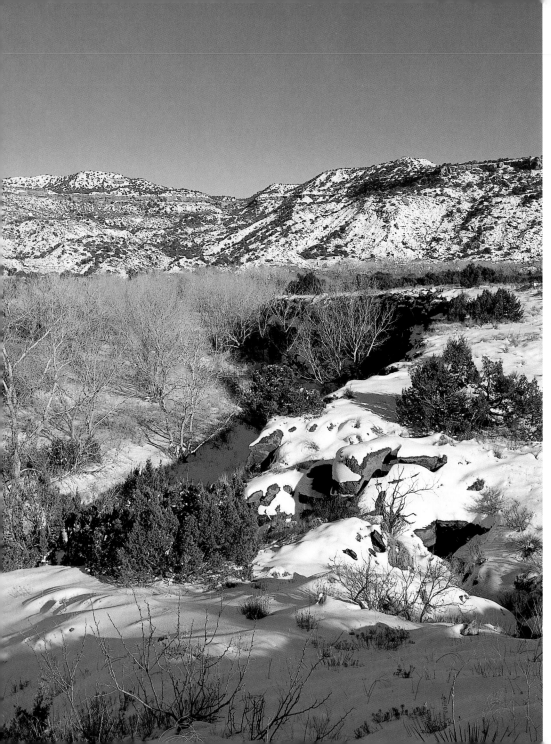

Snow cover along
Prairie Dog Town Fork
of Red River, Palo Duro
Canyon State Park
Hasselblad 501CM; Zeiss
Planar T* 80mm f/2.8;
Fujichrome Velvia

Winter in Palo
Duro Canyon
State Park
Hasselblad 501CM; Zeiss
Planar T* 80mm f/2.8;
Fujichrome Velvia

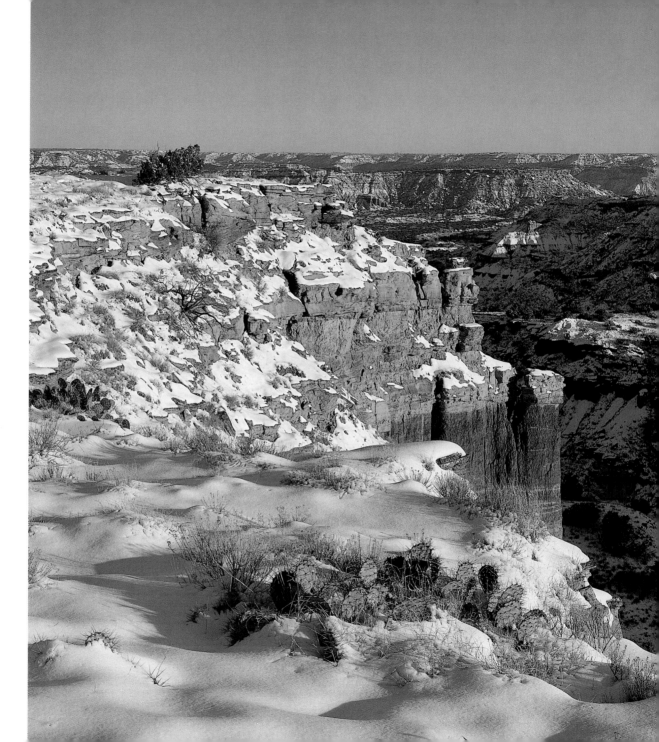

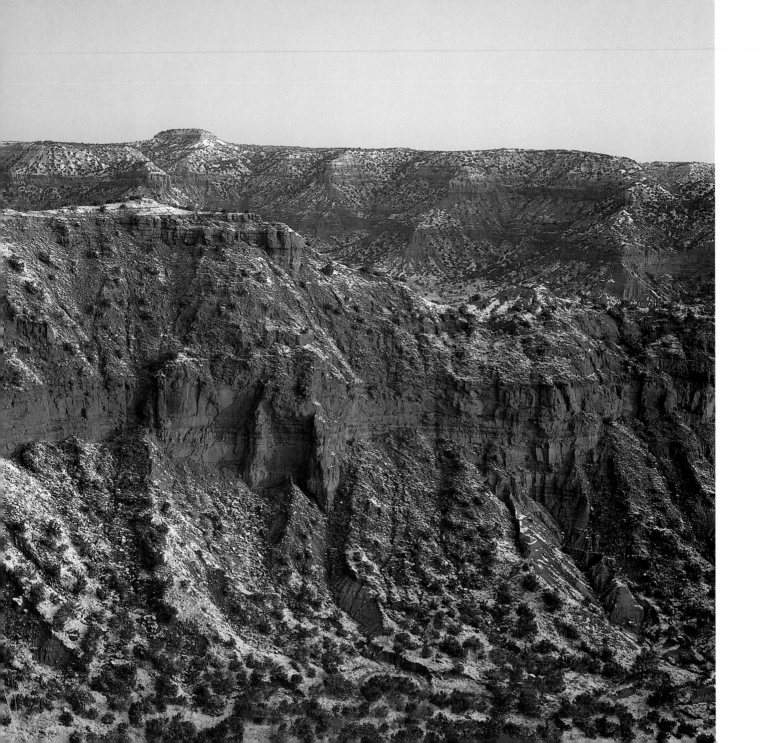

Snow dust, South
Prong Canyon, Caprock
Canyon State Park
Hasselblad 500CM; Zeiss
Planar T* 80mm f/4.0;
Fujichrome Velvia

"Where the sea used to be," Caprock Canyon State Park
Hasselblad 500CM; Zeiss Planar T* 80mm f/2.8 with 1.4 extender; Fujichrome Velvia

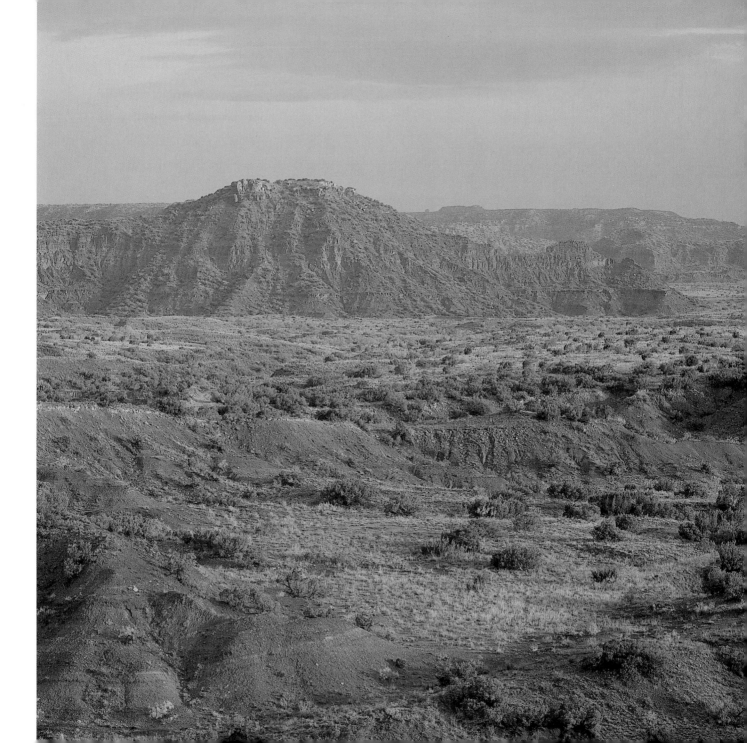

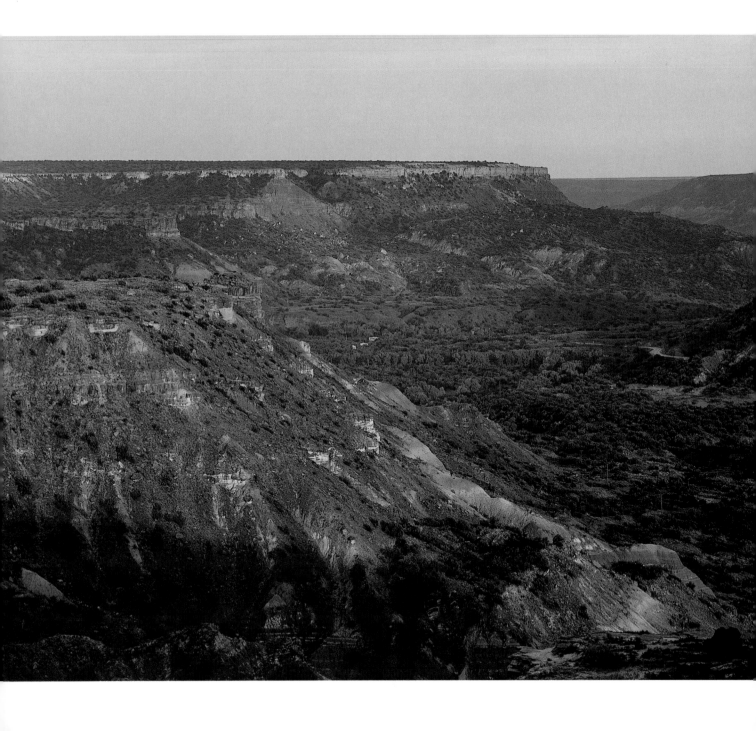

Palo Duro Canyon
State Park. The
water-bearing Ogallala
formation looms atop
the far canyon wall.
Canon F1 with AE motor drive;
Canon 80-200mm f/4.0;
Fujichrome Velvia

South Prong Canyon,
Caprock Canyon
State Park, as spring
thunderstorms gather
Hasselblad 500CM; Zeiss
Planar T* 80mm f/2.8;
Fujichrome Velvia

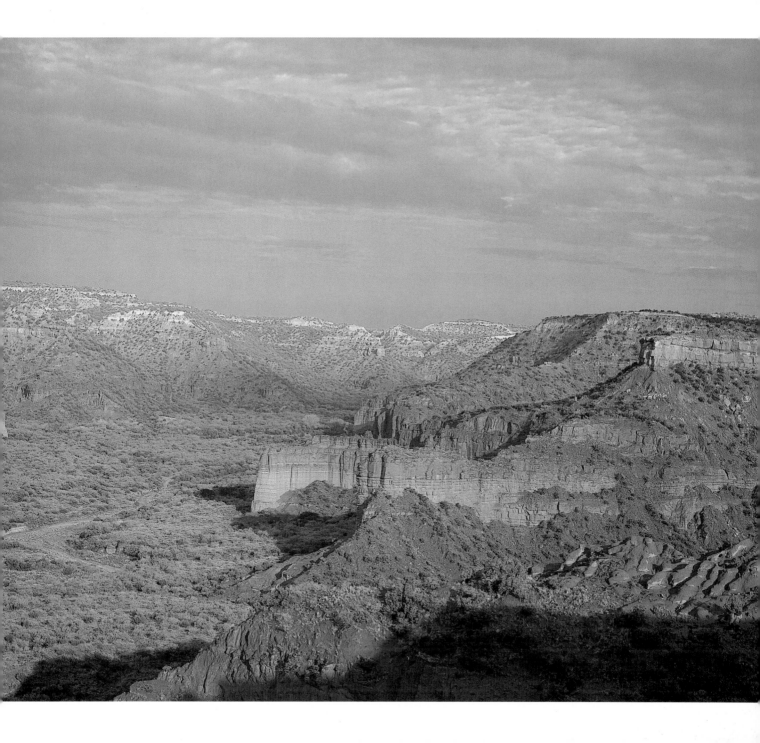

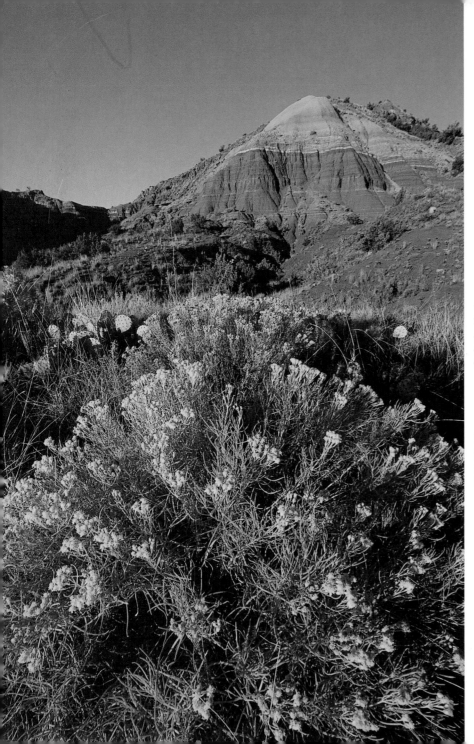

False broomweed, harbinger
of springtime, beneath
Spanish Skirts, Palo Duro
Canyon State Park
Canon F1 with AE motor drive;
Canon 14mm f/2.8; Fujichrome Velvia

Late winter snow,
Palo Duro Canyon
State Park
Hasselblad 500CM; Distagon
50mm f/4.0; Fujichrome Velvia

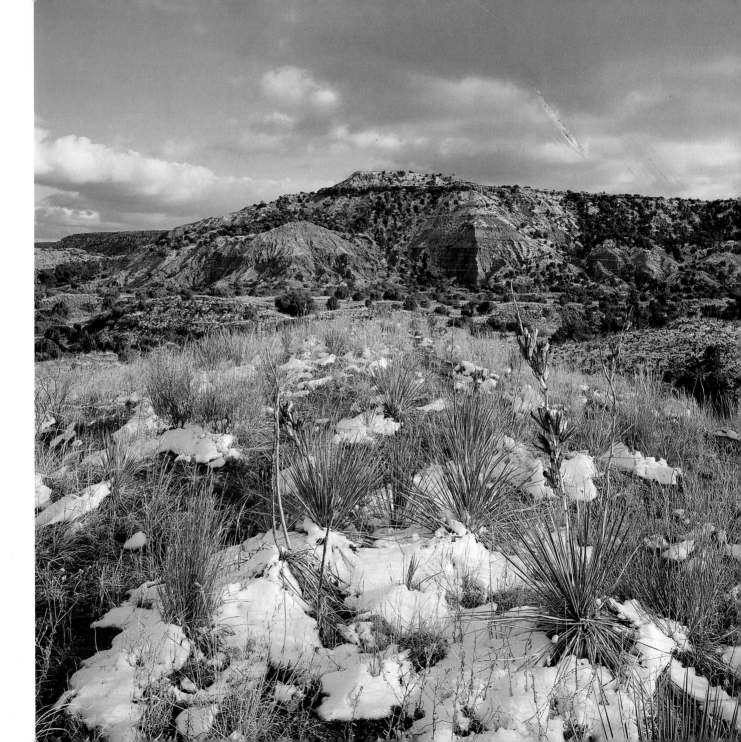

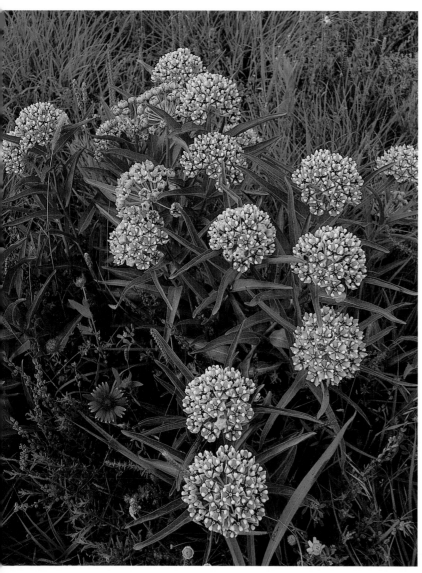

Antelope Horn,
Palo Duro Canyon
State Park
Hasselblad 500CM; Distagon
50mm f/4.0; Fujichrome Velvia

Yucca and sandstone,
Palo Duro Canyon
State Park
Hasselblad 501CM; Zeiss Sonnar T*
150mm f/4.0; Fujichrome Velvia

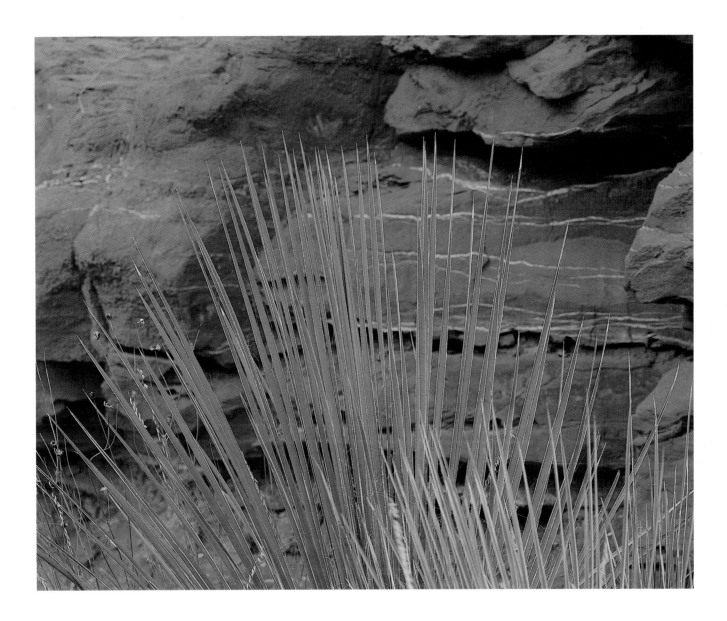

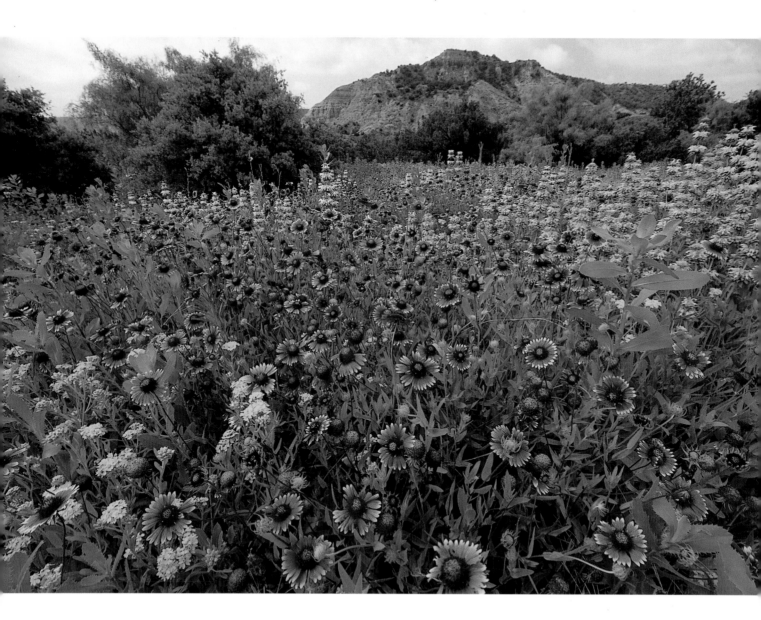

Wildflowers of
Palo Duro Canyon:
Paper Flower, Plains
Horsemint, Gaillardia,
Indian Blanket.
Canon F1 with AE motor drive;
Canon 14mm f/2.8L; Fujichrome Velvia

BIBLIOGRAPHY

Baker, T. Lindsay, ed. *The Texas Red River Country: The Official Surveys of the Headwaters, 1876.* College Station: Texas A&M University Press, 1998.

Bass, Rick. *The Sky, The Stars, The Wilderness.* Boston: Houghton Mifflin Company, 1997.

Kendall, George W. *Across the Great Southwestern Prairies.* 2 vols. Ann Arbor: University Microfilms, Inc., 1966. (Often cited as *Narrative of the Texan Santa Fe Expedition.*)

Kirkpatrick, Zoe Merriman. *Wildflowers of the Western Plains.* Austin: University of Texas Press, 1992.

Marcy, Randolph B. *Exploration of the Red River of Louisiana, in the Year 1852.* Washington: Beverley Tucker, Senate Printer, 1854.

Mares, Jose. "Santa Fe to Bexar, July 31 to October 18, 1787, and Return, in 1788," in Noel M. Loomis and Abraham P. Nasatir, *Pedro Vial and the Roads to Santa Fe.* Norman: University of Oklahoma Press, 1967.

CANYONS